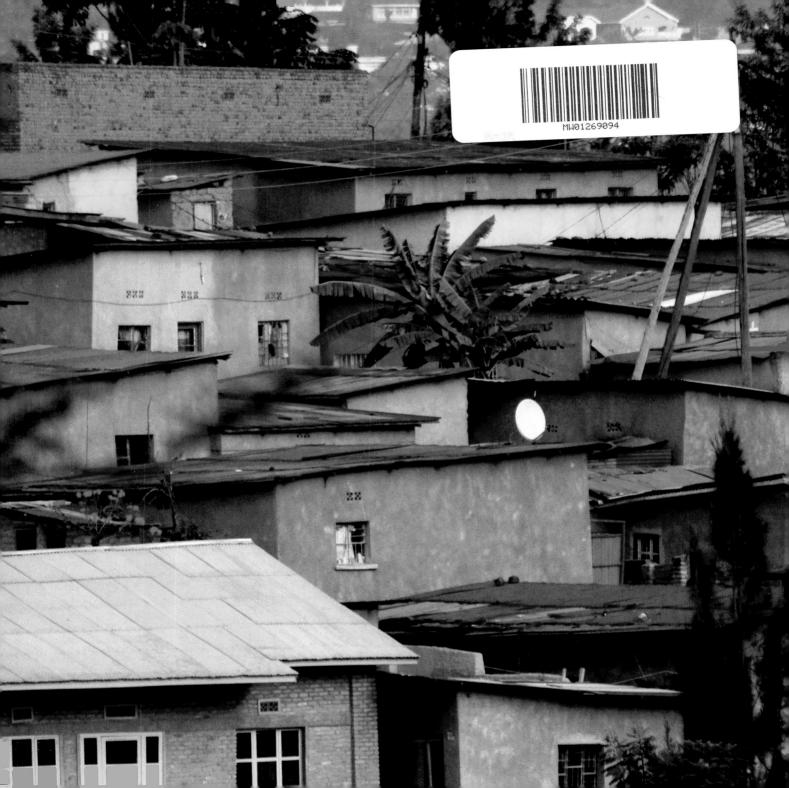

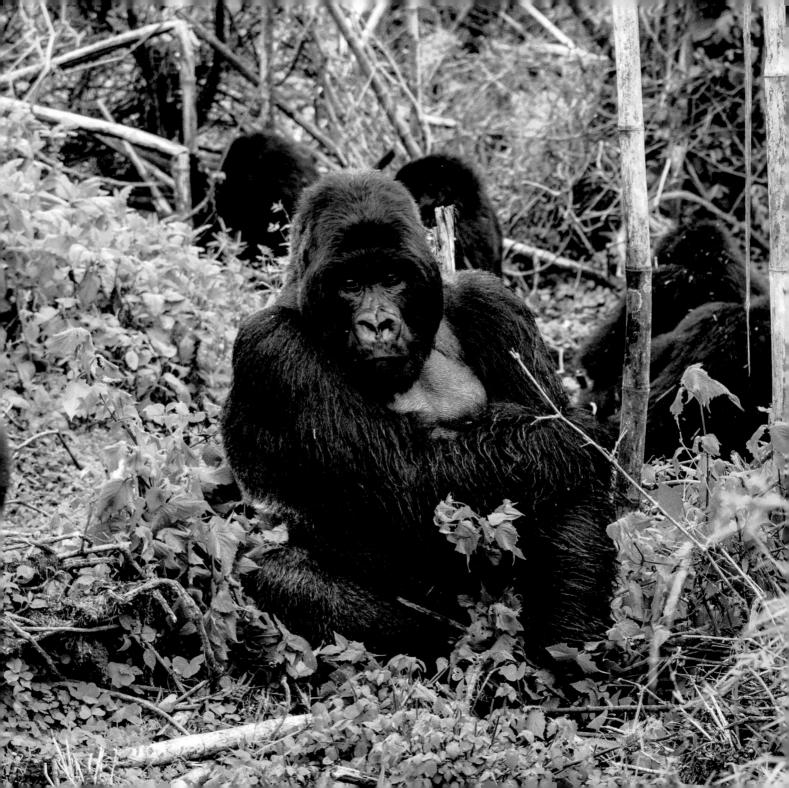

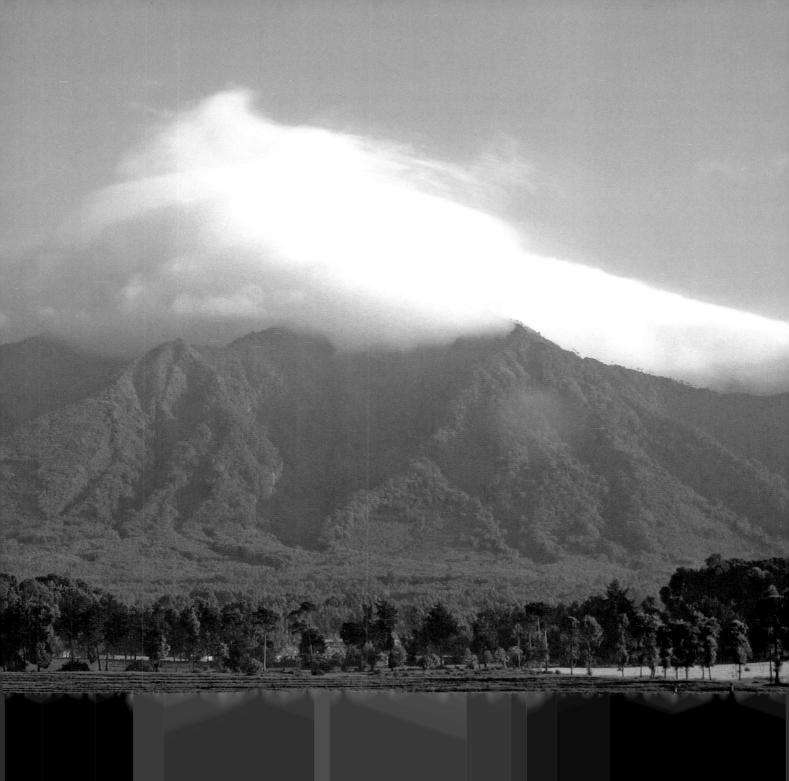

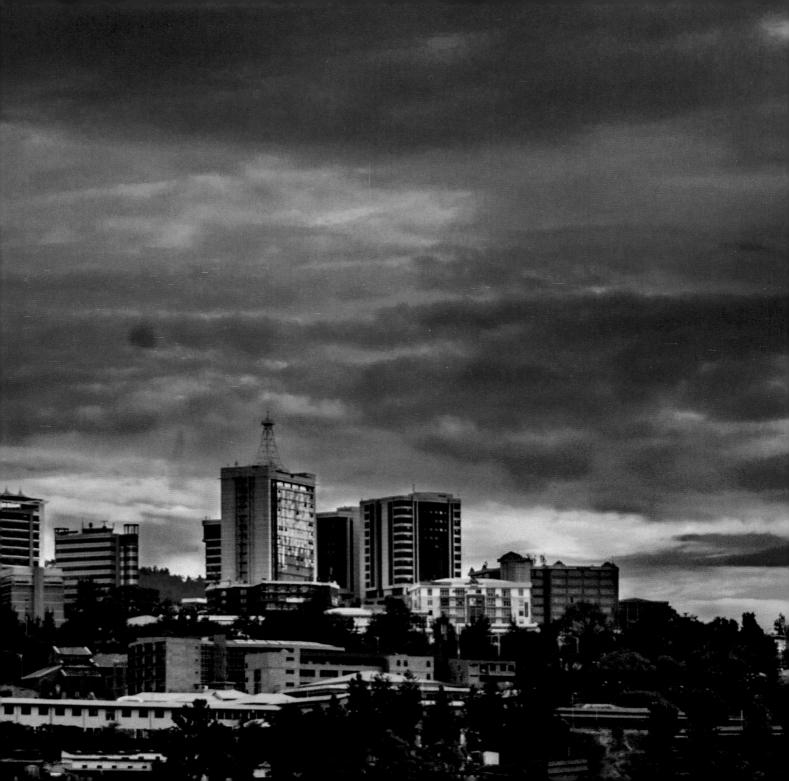

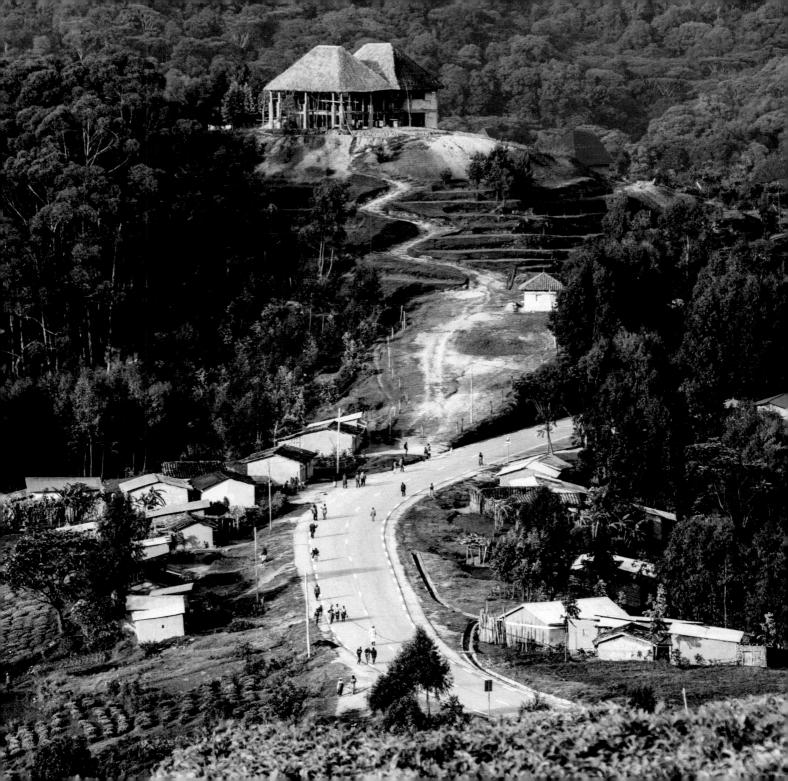

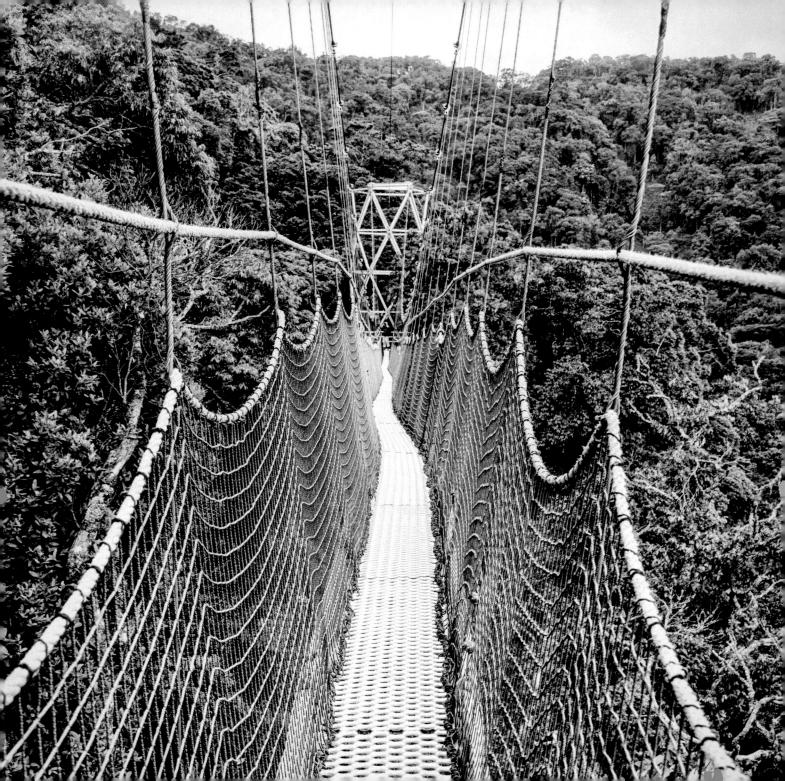

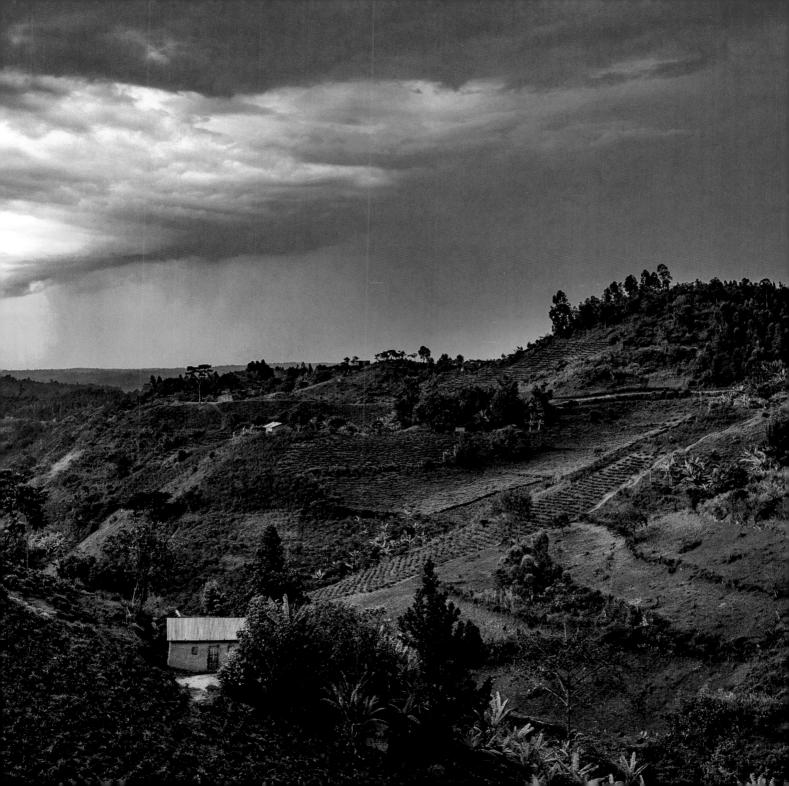

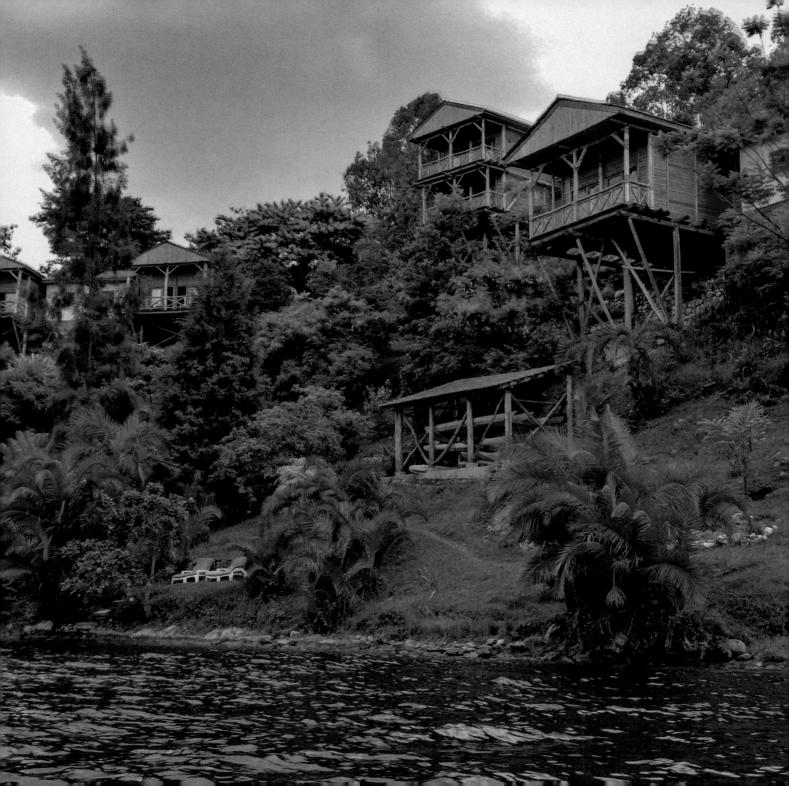

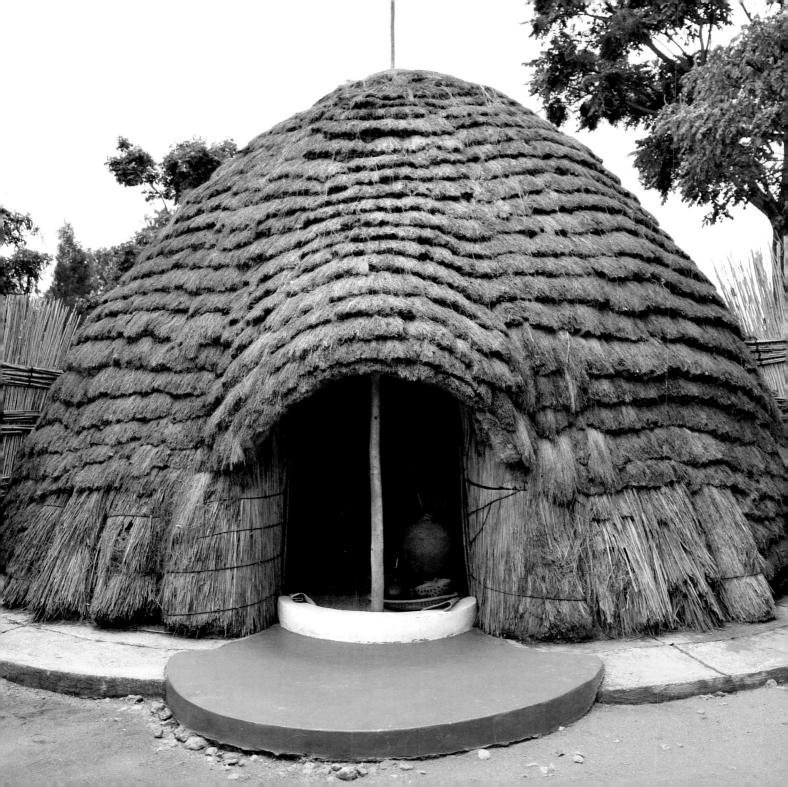

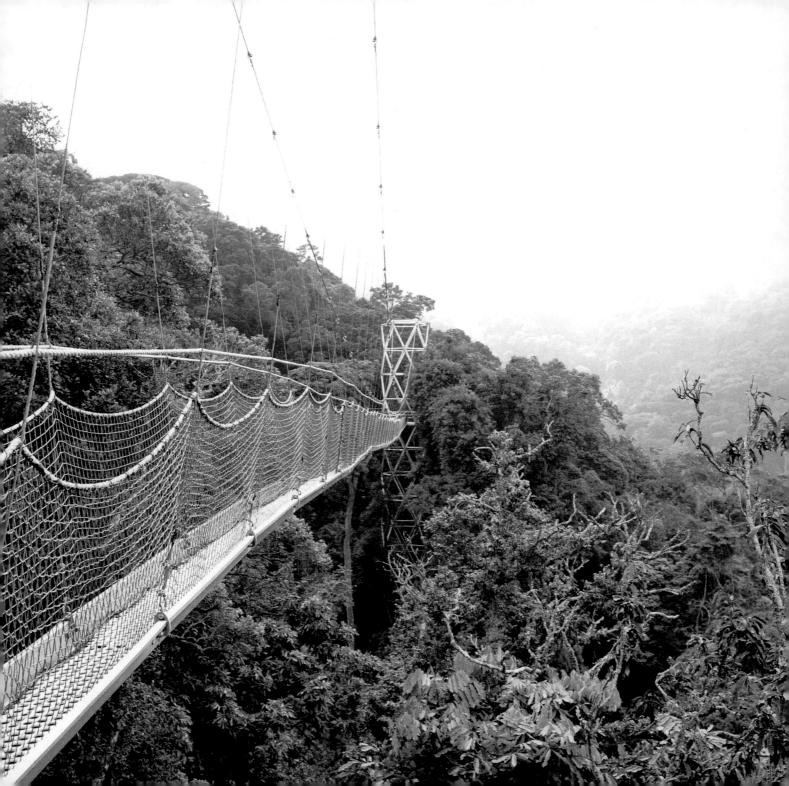

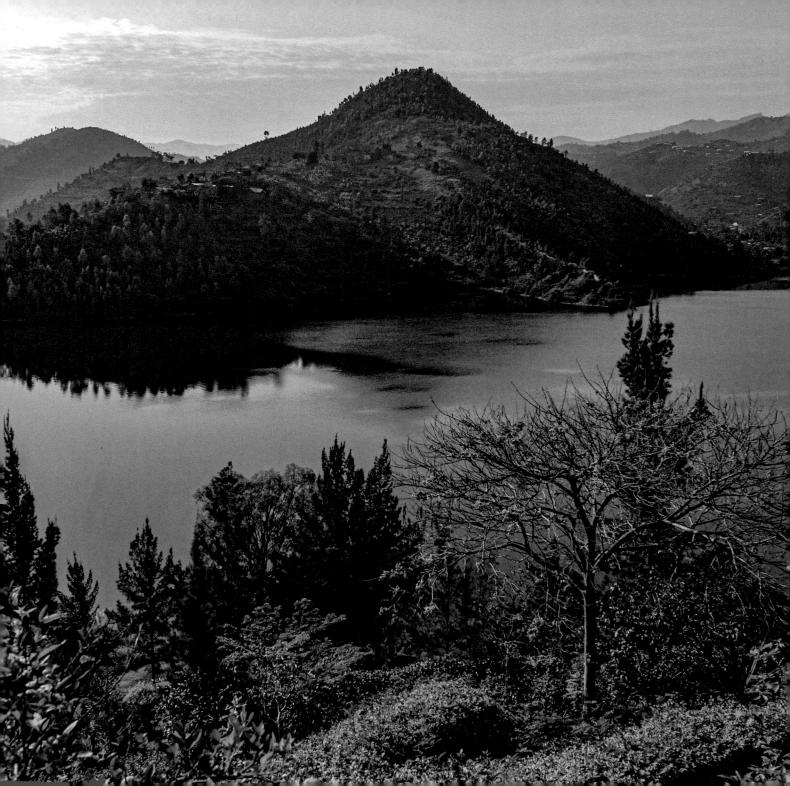

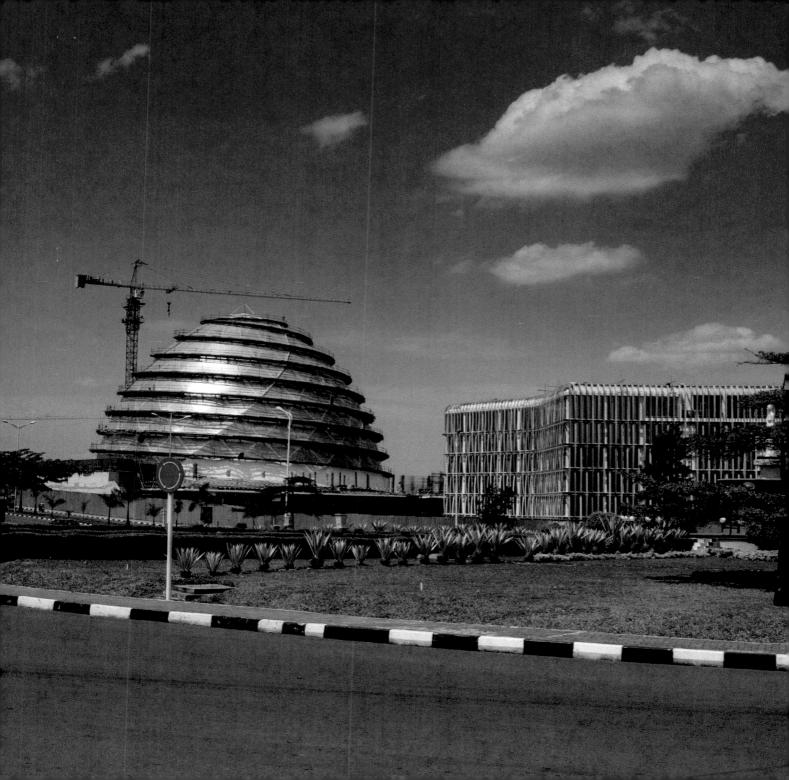

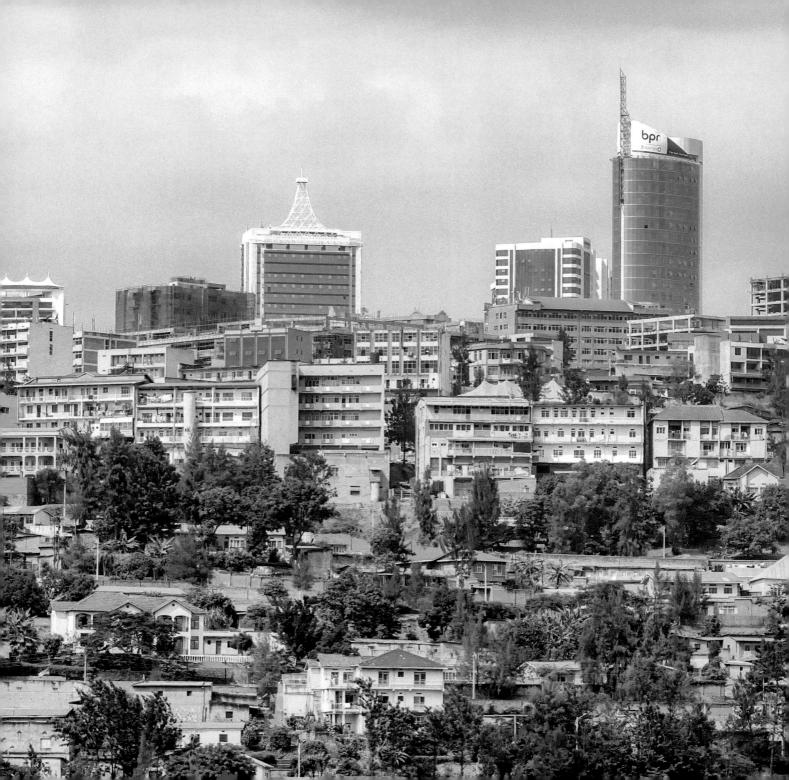

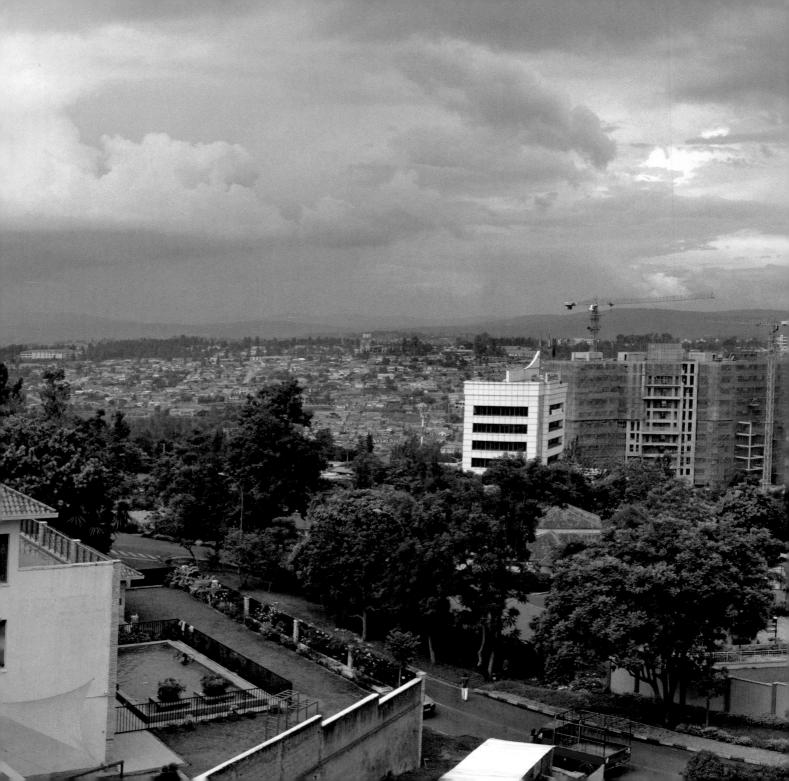

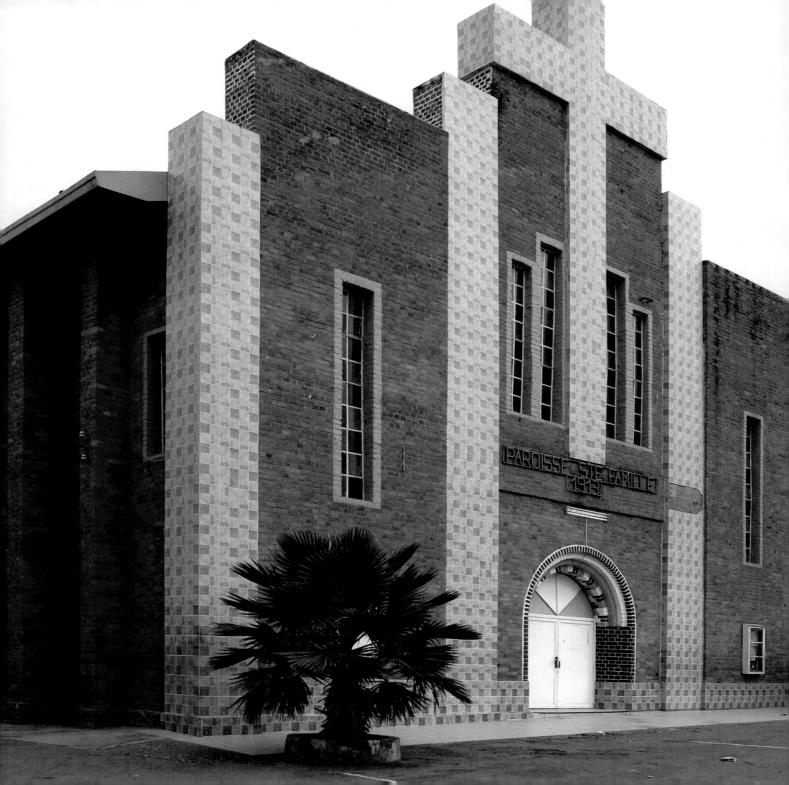

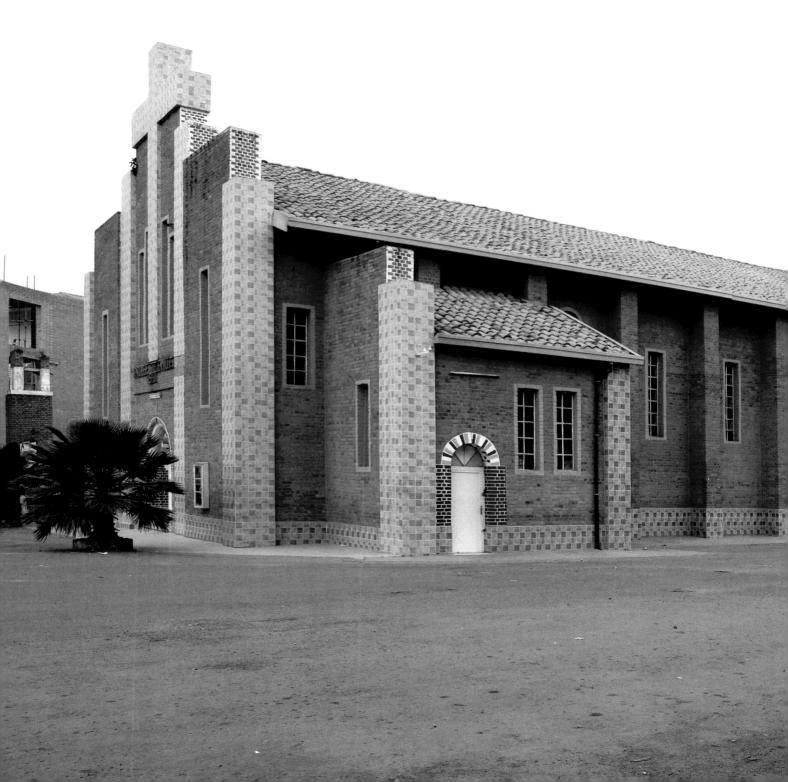

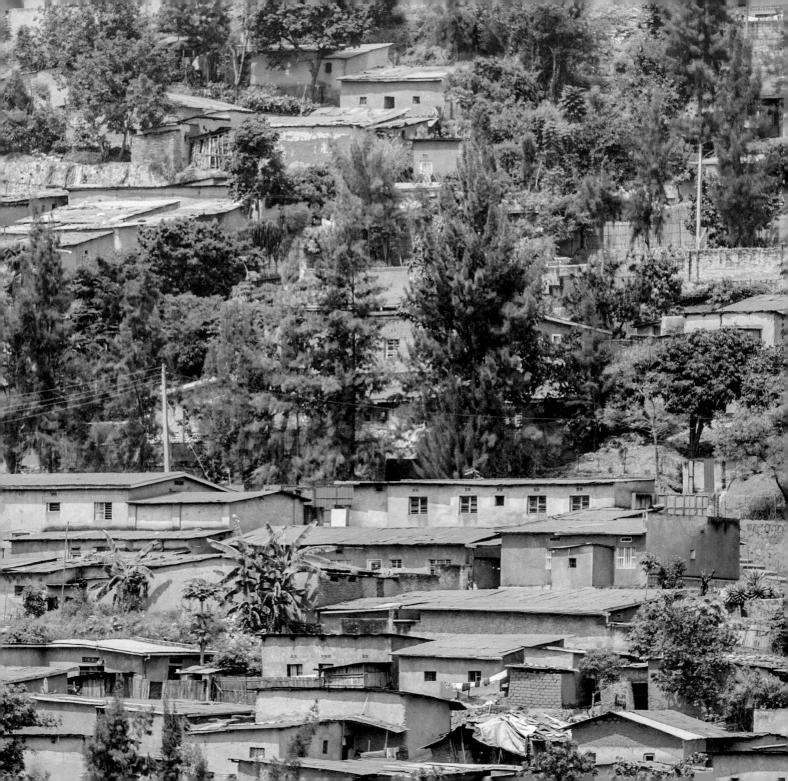

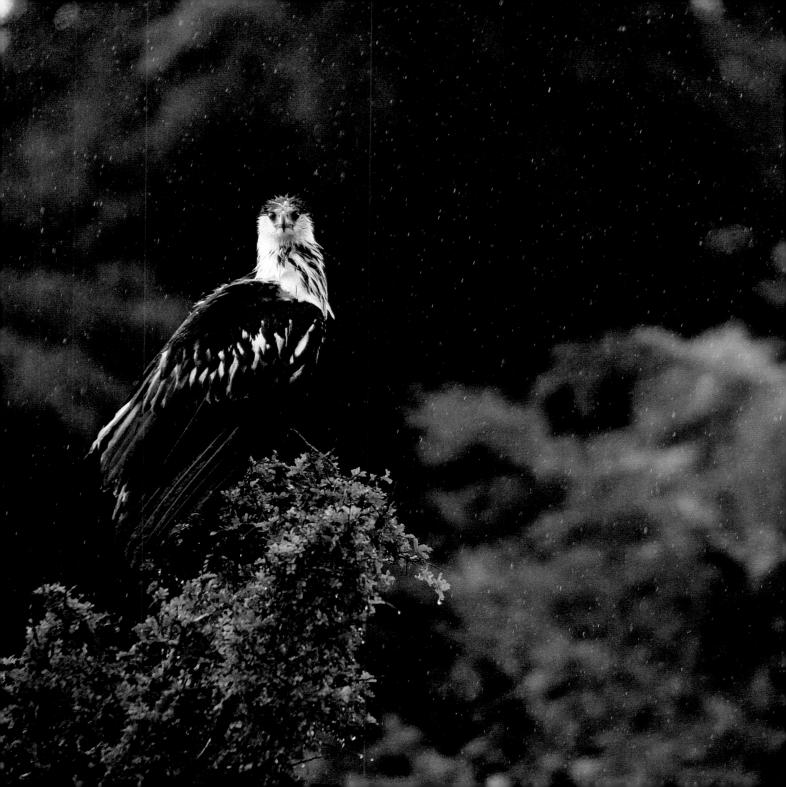

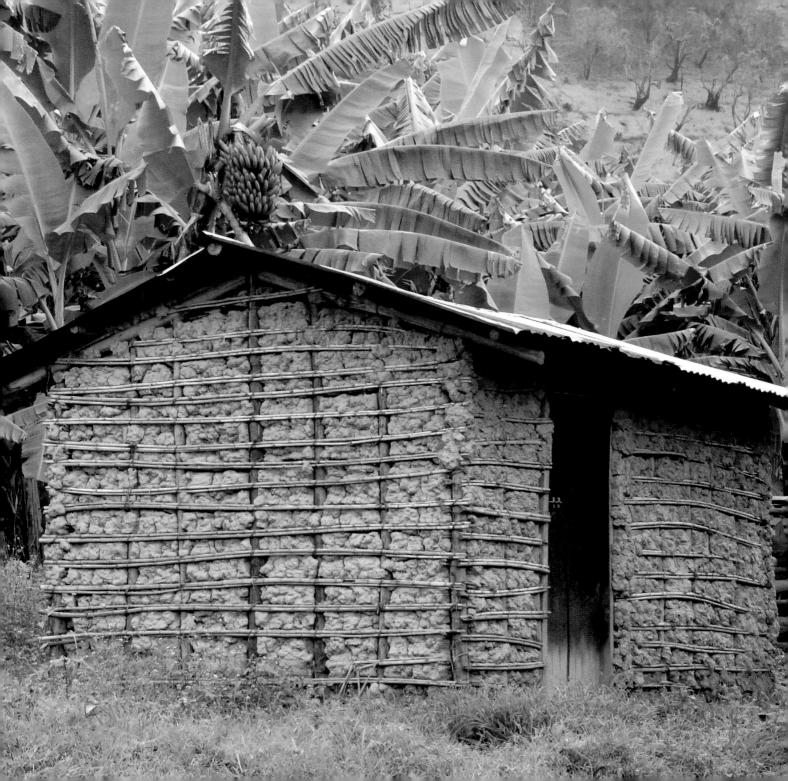

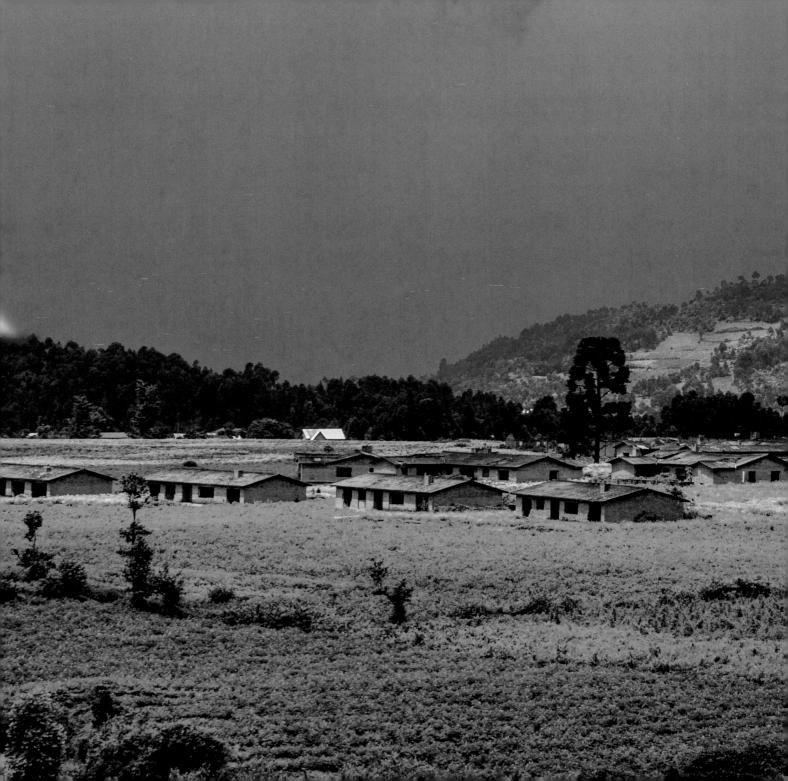

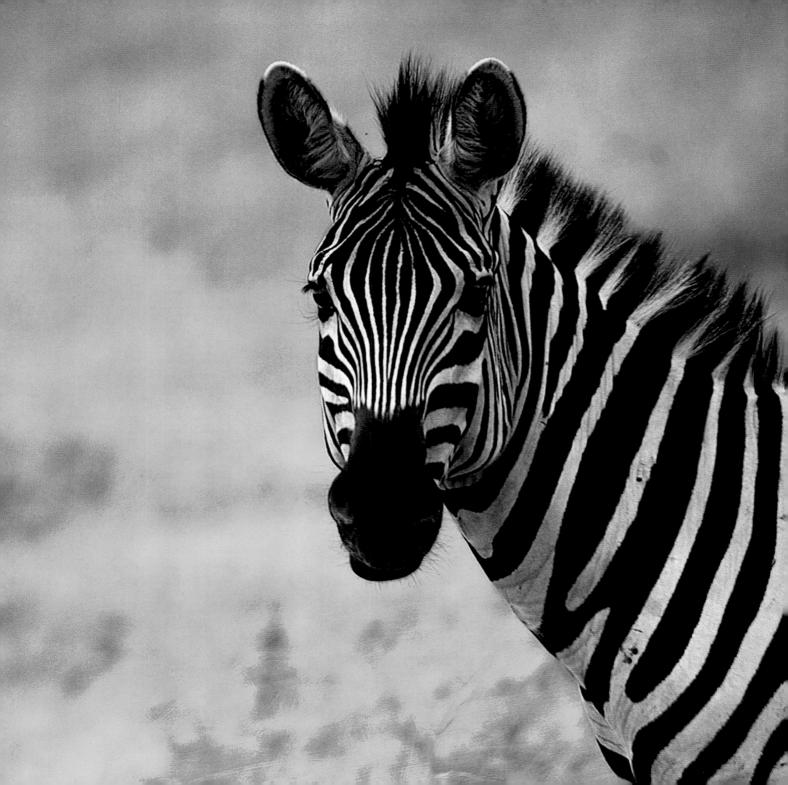

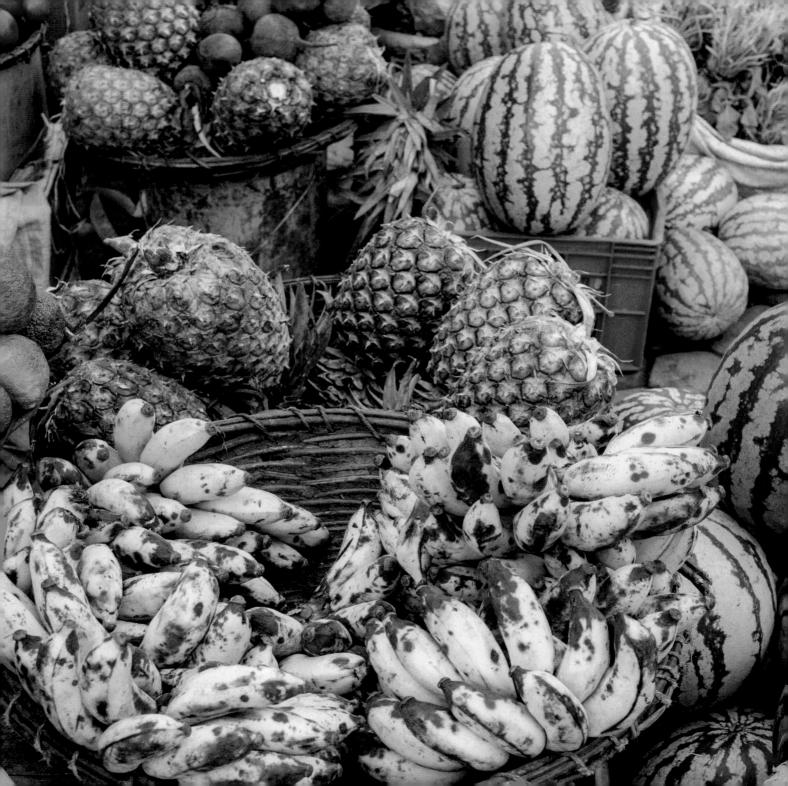

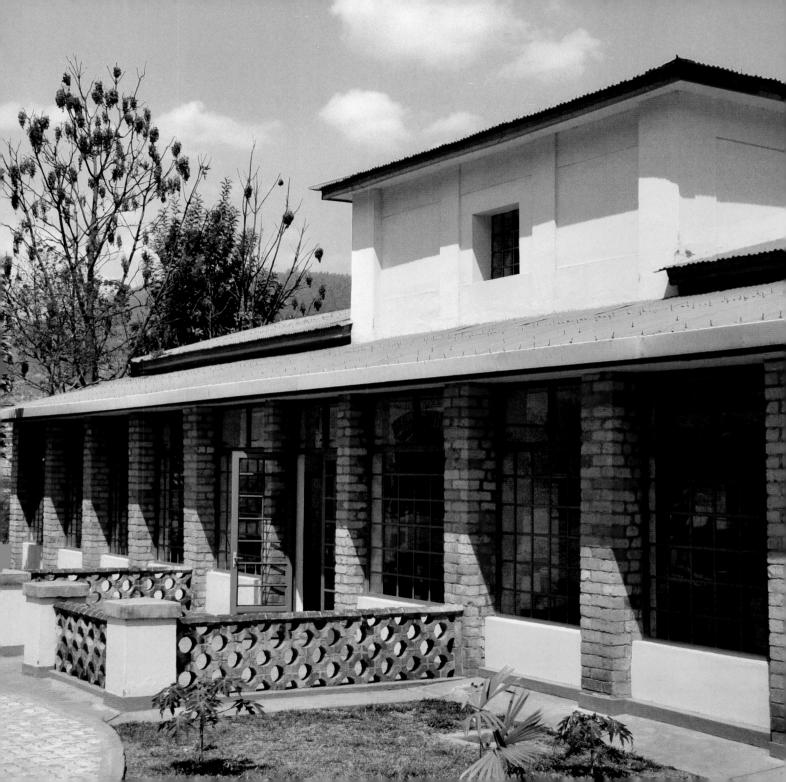

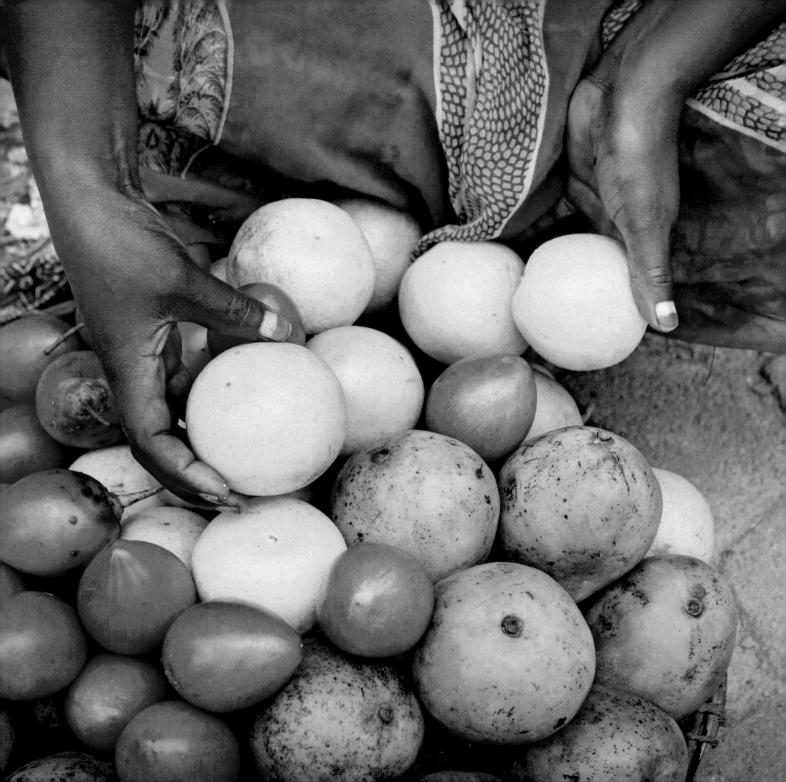

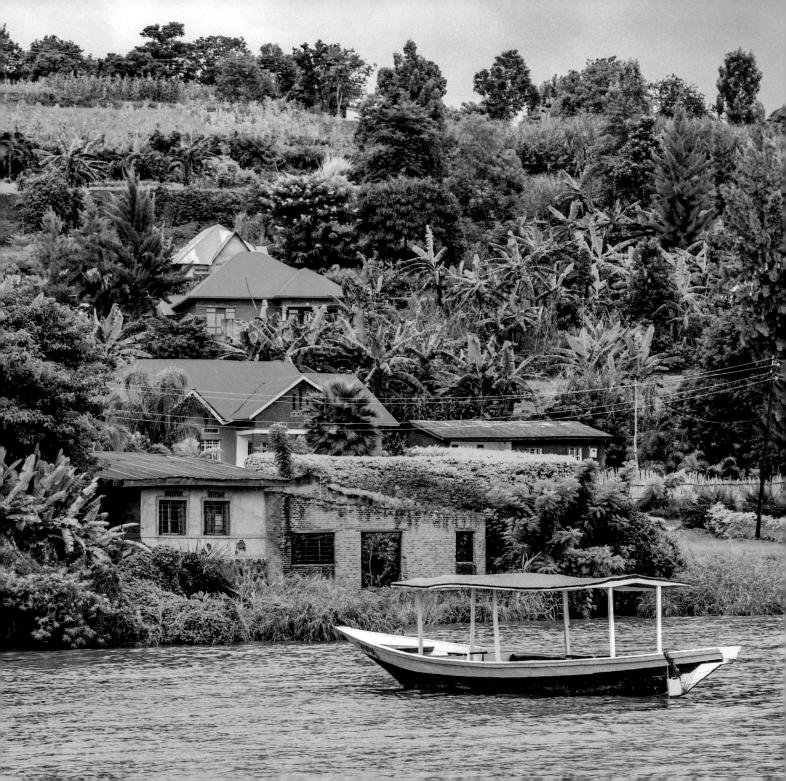

Made in the USA Las Vegas, NV 12 May 2024

89849608R00026